Art and Insights from Dorothy Maclean

Art and Insights
from Dorothy Maclean

ISBN: 978-1-939790-37-8

Edited by Freya Secrest

Maclean, Dorothy
Art and Insights from Dorothy Maclean/Dorothy Maclean

Limited Edition – January 7, 2020

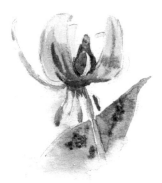

Published by Lorian Press LLC
Holland, Michigan
www.lorian.org

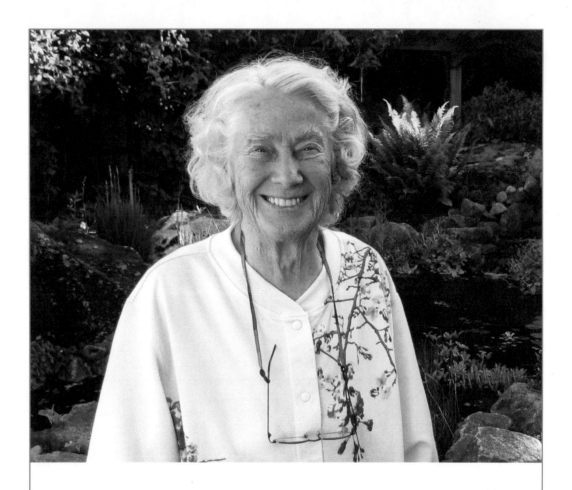

In honor of

Dorothy Maclean

celebrating her 100th Birthday

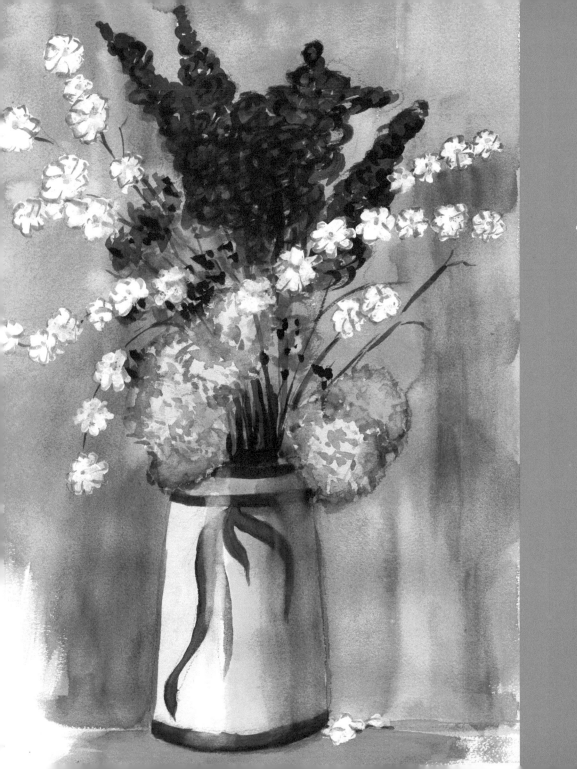

D. Trachan

Dorothy Maclean is an author, speaker, world traveler, wise friend, and a self-styled "ordinary mystic" with a deep attunement to the Sacred in the world. Born in Guelph, Canada on January 7, 1920, Dorothy was raised in a traditional, loving household. As a young woman, Dorothy wanted to go to art school, but weighing out her options, she made the practical decision to take up a secretarial course. After graduating from college in 1941, she joined the war effort as a secretary for British Security Coordination in New York. This path led her to South America and then London where she was introduced to Sufism and other spiritual approaches. She began studying with a teacher, Sheena Govan whose teachings on love also drew Peter and Eileen Caddy.

In 1954 as Dorothy sought to take a step of unselfish love in her life, she had an experience of the 'God Within' that changed her completely. That moment's knowing of herself as a part of a vast and boundless love was the beginning of a daily commitment to turn to and trust in her attunement to her inner divinity. Following that inner knowing has been an unshakable constant for Dorothy throughout the rest of her life. In 1962, she, along with the Caddys, came to live in the Findhorn Bay Caravan Park in Northern Scotland. They were committed to following their guidance and to be more loving whatever happened. On the foundation of that trust and commitment a thriving community has evolved.

Dorothy's early, daily training to honor and live by the wisdom of her own inner divinity was a doorway that opened her to the Divine in all of life. In 1963 as Peter was trying to start a garden to supplement their diet, she was asked from within to connect to the essence of Nature. Thinking of the garden pea, a familiar vegetable she loved, Dorothy felt into its essence in the same way she approached her inner attunements. She aligned to what she knew of the pea's essential qualities—color, taste and scent—and felt an immediate and intelligent response. So began the unique relationship between these nature intelligences and the human gardeners that resulted in the renown Findhorn Garden. Dorothy's name for these intelligences was 'Devas', a Sanskrit word for "Shining Ones." When the gardeners cooperated with these devic beings, their gardens flourished. Dorothy's commitment

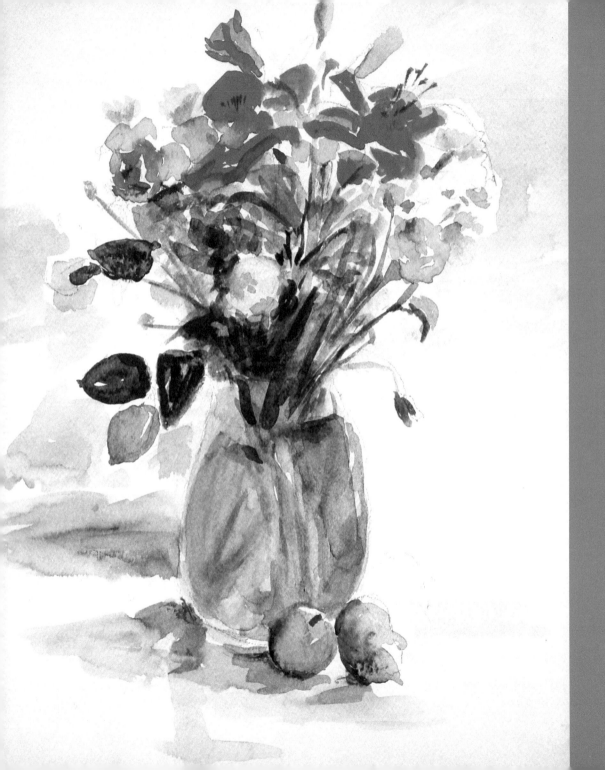

to recognize, learn about, and live in the transforming power of love, God's love. amplified and deepened.

In 1973 Dorothy left Findhorn responding to a call to travel and teach. Her fear of public speaking was a hurdle in following this inner prompting, but when something came from that inner source, she knew she needed to step out to follow it. For over 35 years she traveled and taught around the globe speaking in simple and direct ways about how each person could make an inner contact for themselves. She offered guideposts and encouragement by sharing her own stories, for as she said, "If I can do it, anyone can!" Dorothy's life and work in every way celebrates Love as the great source and power behind all life, honoring that Love as "within and open to all of us."

It was not until she was living in Toronto in the 1980's, forty years after leaving Canada, that Dorothy had the opportunity to go to art school. As someone who was always sketching in her notebooks, she was delighted at last to give full attention to exploring her love of color and painting. Most of the watercolors and drawings included here are personal projects from her art school experience.

Part of Dorothy's ability to contact the divine in the world around her came from her "artist's eye." She has always been aware of her physical environment. Wherever she goes, she notices and delights in the physical beauty around her. Her joy and appreciation of beauty as a doorway to the essence of life within and around her stands at the heart of her connection to the Sacred in life.

The reflections in this book are excerpts from her many messages from the God Within and the Devas. Both as an artist and a poet she draws us into the rhythm, flow and magic possible when we awaken to Love and give it expression through our daily life. Enjoy the quotes and paintings as one person's celebration of the spirit within matter, as one window into the heart and energy of life. Honor them by allowing them to draw you more deeply into your own relationship with Love and the Sacred in Life.

Freya Secrest – January 2020

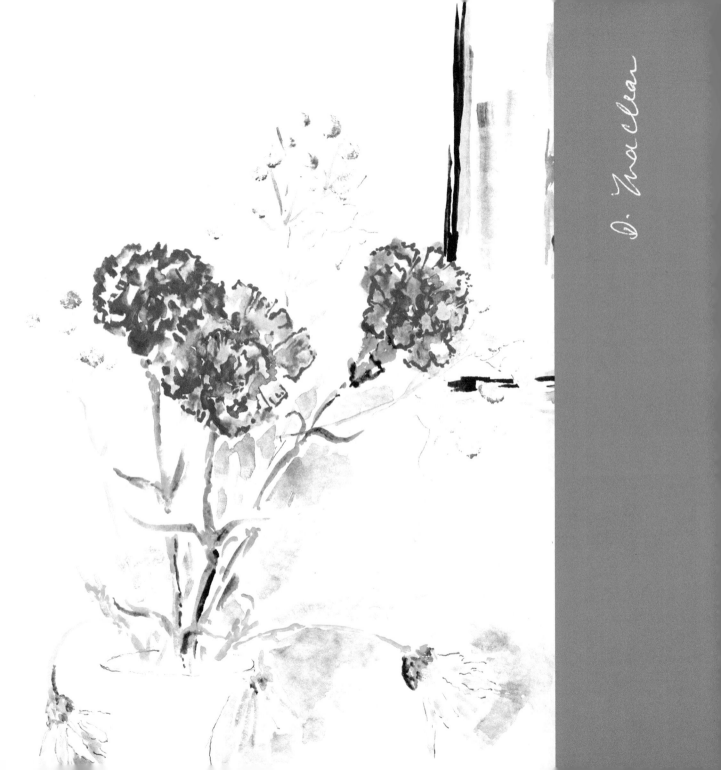

There is nowhere where I am not. You may tune into a flower, a caterpillar, the sky, and I will be there speaking indirectly. You open your eyes and see My handiwork; you listen and hear My creation. Through all the senses I am evident if your consciousness is alive enough. But from within I speak directly in a voice from the depths you cannot plumb, and from within I fill all space.

Now relax in My presence, do not strain over it. It simply is, and is always available. Trust it and it will never fail you. Love Me, love My creation, love your situation and we will be One always.

— The God Within

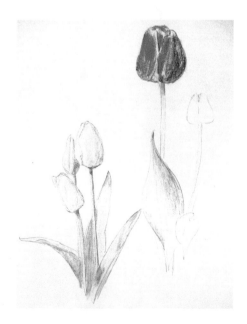

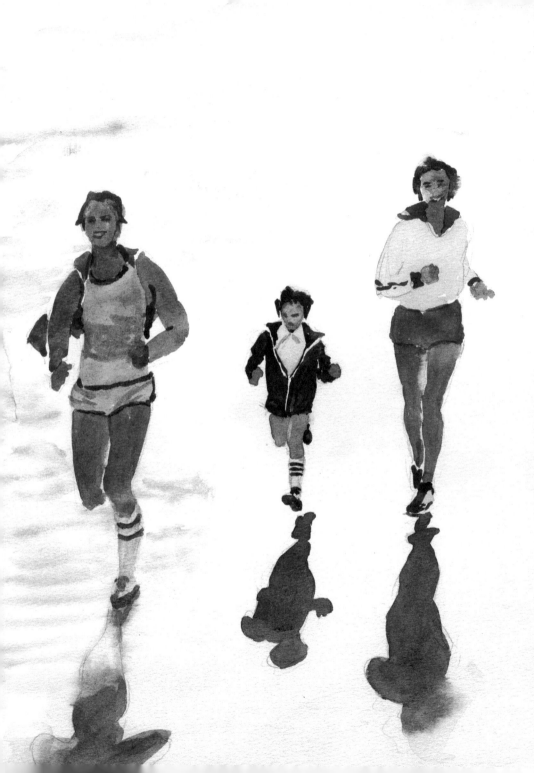

D. Maclan

To live closely with Me, to be truly yourself, there must be freedom of the spirit. Between you and that freedom lie all the little things, all the so-called sins of omission and commission, the acts covered by the moral injunctions of the world, the judgments you make, the reactions you have, the strong opinions you hold, the things you do imperfectly. The spirit cannot flow properly and you cannot be personally free of your lacks until you cease resisting, drop your limitations and flow with the present moment. This means that you joyously meet your responsibilities, living in the moment without comparison of past, future or another.

You may see all this with the mind. Theory alone is useless, and the best way to put it into practice is by loving. You do not judge your neighbors when you are loving them. You do not react negatively when you are positively loving. You are free from your own lacks when you are actively loving another. You do what you are doing well when you love what you are doing. It is so simple. You have freedom of the spirit. Claim it. Freely love Me.

— The God Within

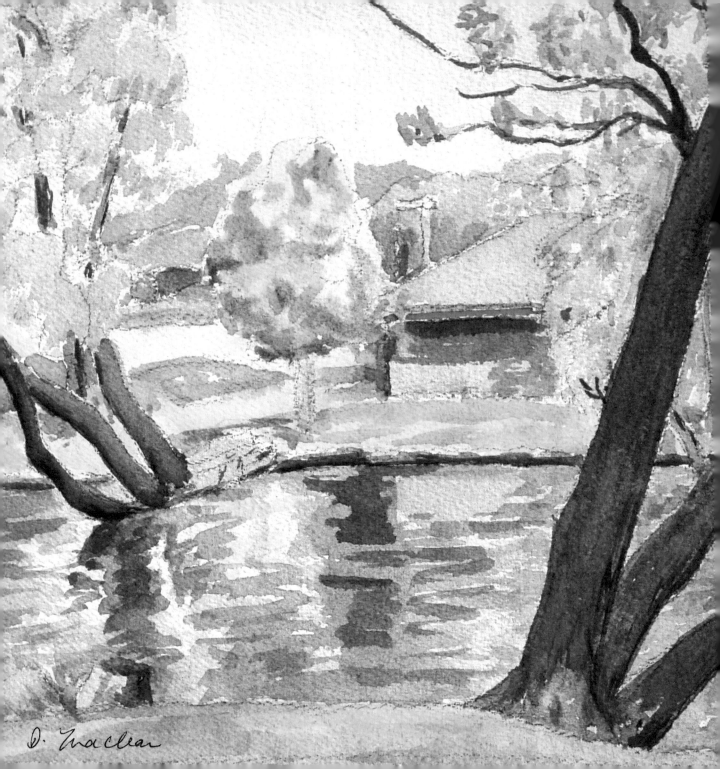

Pour love into your situation, whatever it is. In the middle of the night when all is still, let love flow forth. Do not let the busy-ness and habits of the day divert you from doing this. In the flow of love all are united and all is well. The world outside, the life in nature, and the life in the mighty intelligences which enfold this Earth in their love, are in harmony with you. Then joy floods your being and still more love may flow into your world and out.

As for those moments of the day when something or other bows you down and closes your heart until you look at life through a loveless and harassed eye, see their unreality. See their isolation from the mainspring of life and turn away from them. Whatever the effort, turn towards love for something, somewhere. Then you are in touch with life again. You will have found a little window through which to look upon reality. Love flows forth and transforms the world around, lifting it, redeeming it and making it new.

So love. Love something and let love grow, and I will come. There is much for us to do together.

— The God Within

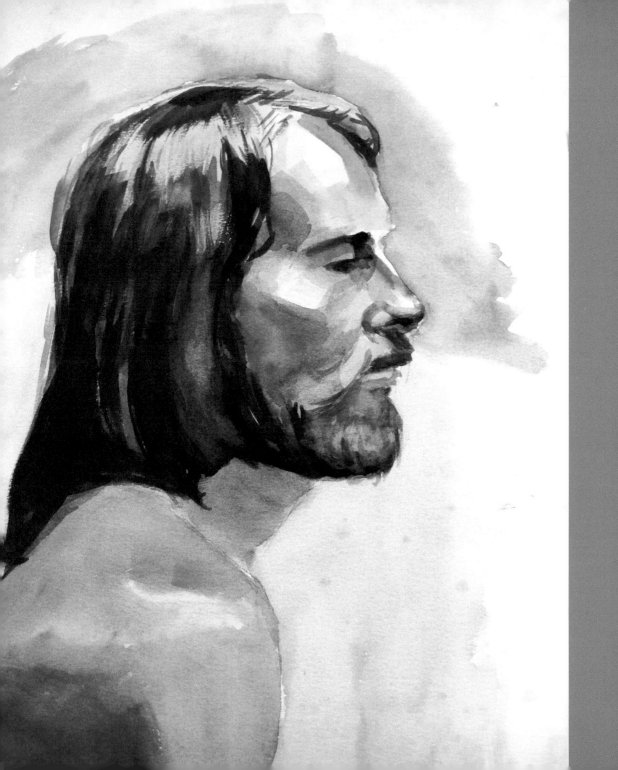

D. Maclean

Unless you come to Me in the silence and attune to Me, you go through life without the slightest idea of what you are. You can go through life with the idea of yourself based on your education, which merely reflects world consciousness and is very mental. You can see yourself based on what you see in the mirror, which reflects the outer form. Or you judge yourself based on your emotional reactions to another, which is totally misleading and limited by all manner of things.

You are more than what you think and feel you are; what you truly are is right here, radiating harmony out to all worlds from the center of you. You can choose to have the joy of knowing Me, of knowing yourself, more intimately in the silence. I am always here.

— The God Within

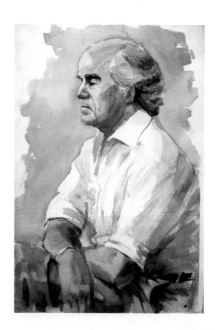

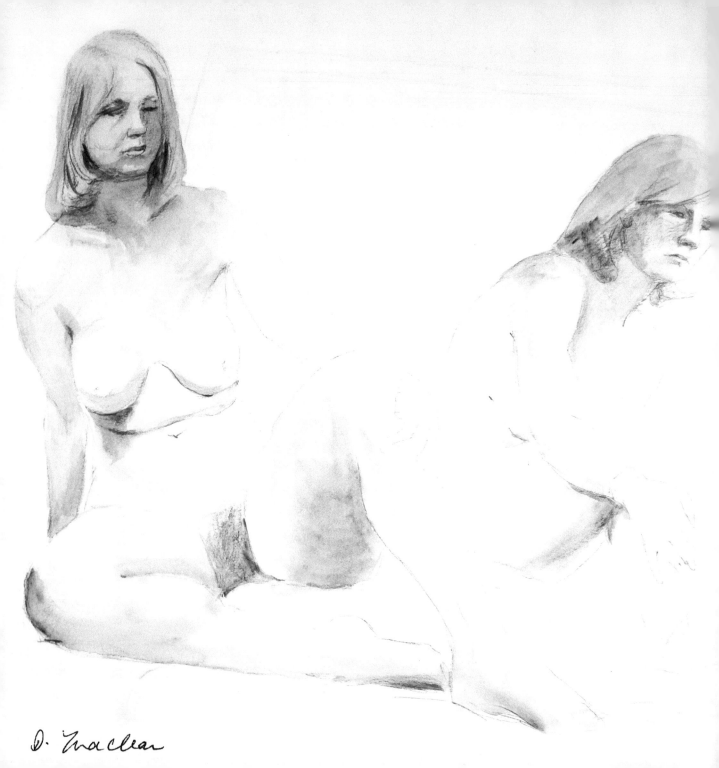

D. Maclean

Love your body. Realize what a wonderfully intelligent instrument it is, and how wonderful it feels with My energies coursing through it. Perhaps you have been vain about some part of it, as if you personally were responsible for some perfection expressed in it. When you become conscious of me as the life force within you, you can truly love your body as the marvelous instrument it is. Like any instrument, it will respond to love.

Take nothing for granted, not even the vehicles which you have considered to be you, as you become more aware of Me and My creation. Give thanks and be full of wonder, and open yourself to a wider consciousness. Then My life and love in you will flow out to My life everywhere.

— The God Within

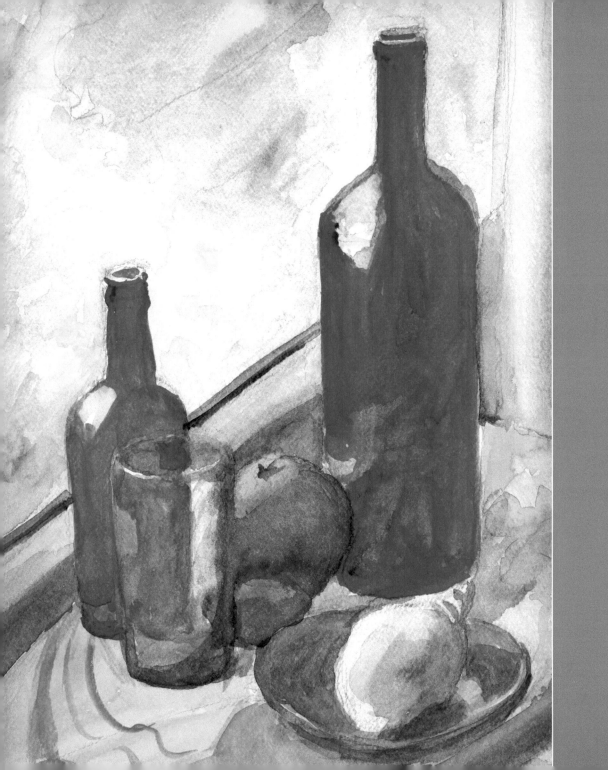

It does not matter how little you know or how much you know, or what you have done in life. I am here and you can attune to Me. There are no rigid rules about this, because I am unique in each one of you, yet forever the same. Each moment of your life you can follow that which is first-rate for yourself.

As you drop your self-concern and turn your attention to the whole, you join the flow which is My love everywhere and you stay attuned. You become filled with wonder and gratitude at this wonderful flow and become increasingly aware of it in your lives and in the lives of others. You are awe-inspired, yet at the same time you are enchanted by the personal aptness and joy which comes with My presence. This never palls and the freshness and newness of our Oneness is a constant miracle, a fountain of delight. For I am your Beloved and all worlds are in our love.

Nothing is left out when you attune to Me. I am closest to you, I am you, within.

— The God Within

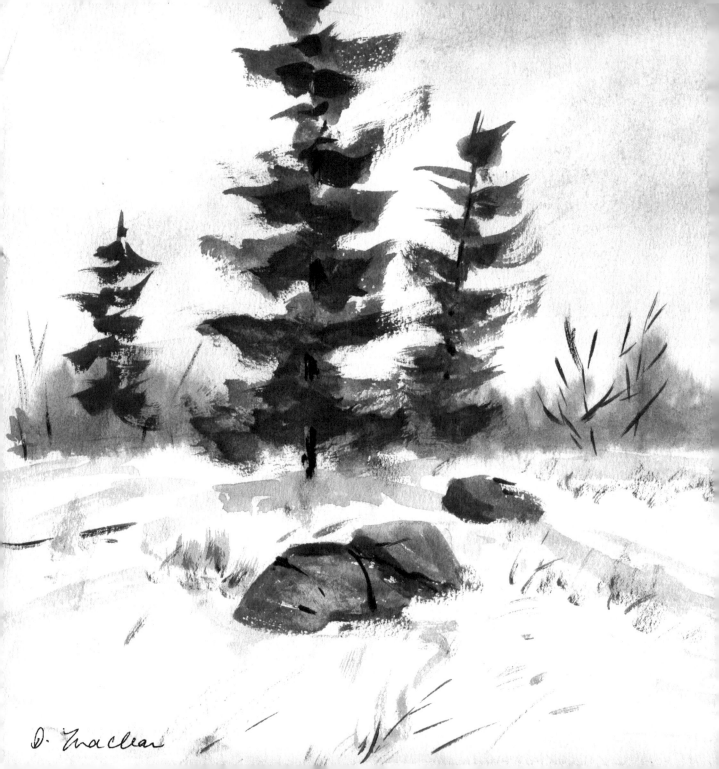

D. Maclean

Our peace that reaches from earth to heaven, from the cosmic height to the depths of matter, our peace that stays steady whatever the noise around, our peace that we radiate out patiently, ceaselessly to a world sadly in need of it, Is here for you. This is one of our functions. We remind you that you too can find this peace through us and through what you have of us within you.

Linger in the forests. Linger near us. Healing comes when you do. All is within. We help you to find it.

Joy is the height of us, but the depth of us is peace. How it grows out and out and out, encompassing the world! We are the symbol of one part of you. Attune to that part of yourselves always so that joy may encircle the world from the roots of the peace of God.

— Tree Devas at Randolph's Leap

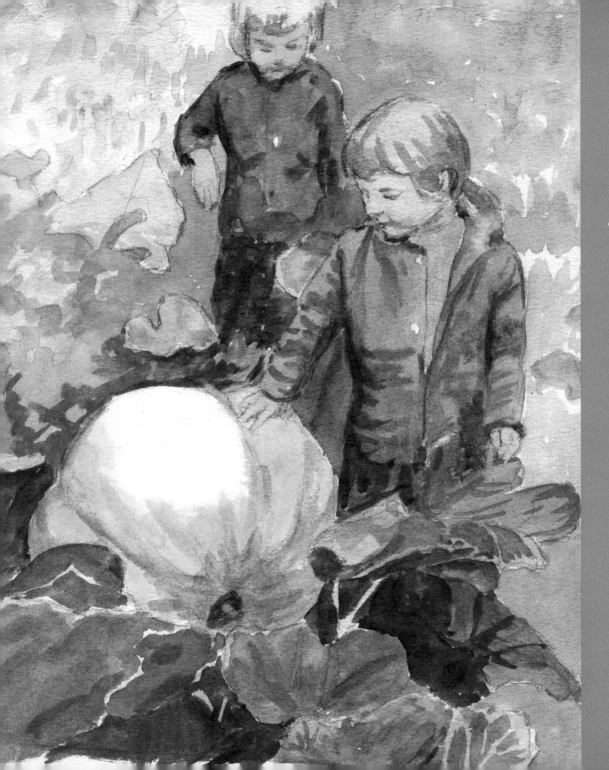

D. Maclean

Love is a bridge between all of the kingdoms of nature. When there is love in your heart, we come closer to you than we usually do and do not feel so different and remote to you. Love not only makes you soft and therefore more approachable for us, it also makes you feel out and therefore move toward whatever you are feeling love for. Love is the only thing that binds us because it makes us want to be bound, makes us want to be close to you. In a different way altogether, it binds us to our work. Love draws us, attracts us, and not only us but all of creation.

— The Devas

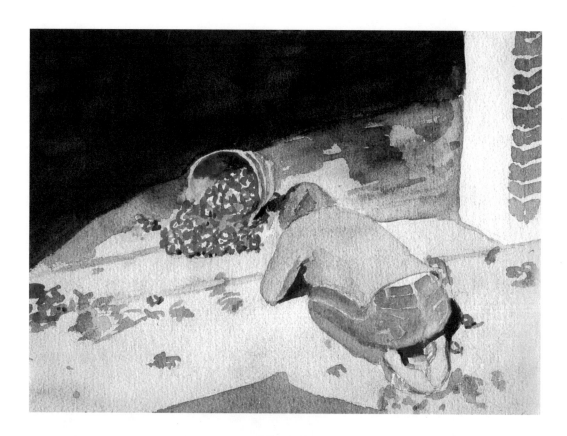

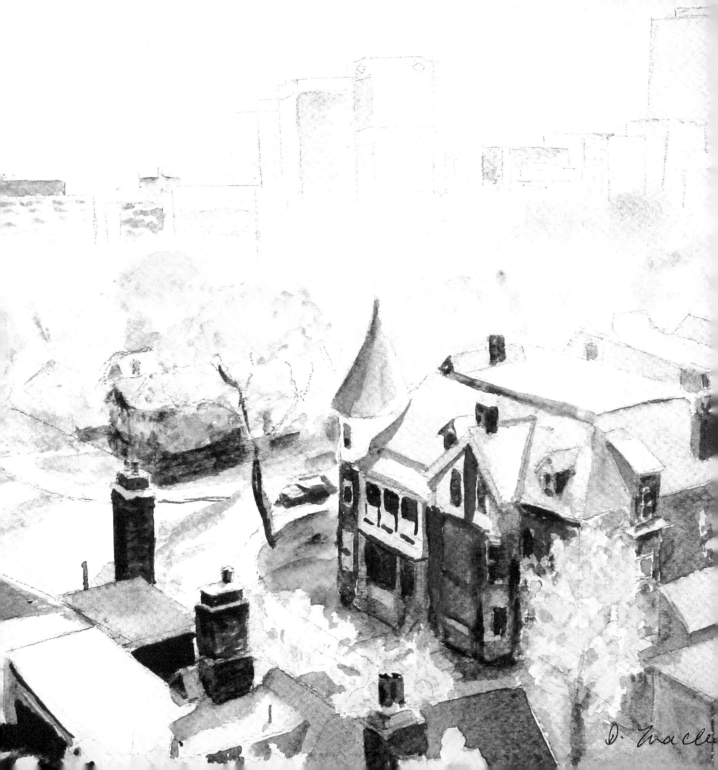

Let love flow out from you to your surroundings. This redeems. This uplifts. It is not just human hearts that respond but all of creation, for it is the life-stream of creation. It does not matter to what the love flows; whatever draws it, receives and is part of the Oneness. It is a creative force. It is felt consciously by the inner spirit of the mineral, vegetable, and animal kingdoms and it is the great initiator of change in them, making them more vital, more part of oneness. Whenever love and praise and joy stream out, the world is touched and responds in some way. When this flows from you at all times, then you are truly expressing your divine nature. Express it as it is drawn forth in the moment and give thanks for it and all worlds rejoice.

— The Devas at Randolph's Leap

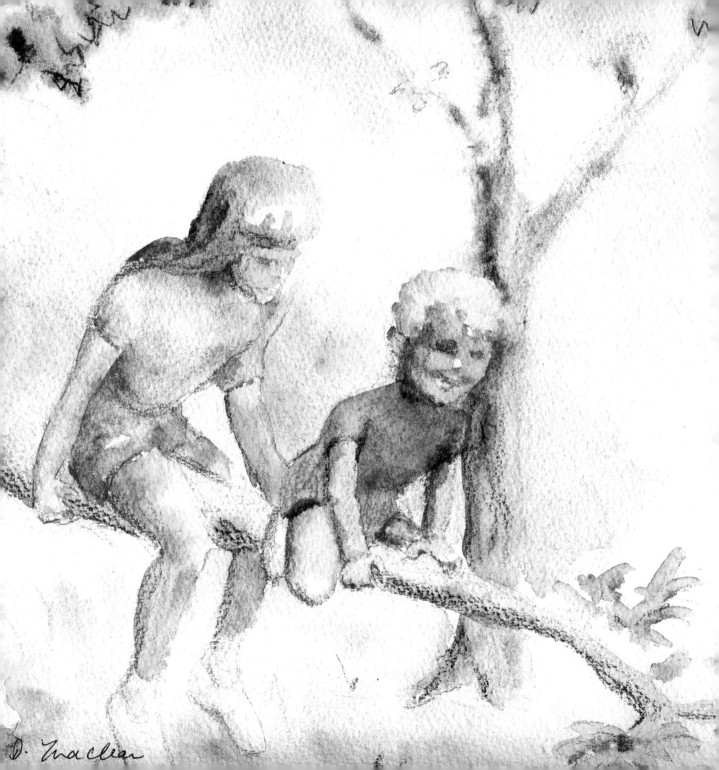

D. Maclean

We want somehow to have you realize and express the joy of life, for all life around you is affected by your attitude. You just don't realize how you affect your environment for good or ill, according to how conscious of God you are and although you are learning how adversely you are affecting it chemically, your motives, your thoughts, your awareness are far more powerful than chemicals.

So, when you are in the garden or wherever you are, love it all in a great torrent of Love as we do and the good you do will be far beyond your expectations and will act, react, cleanse and purify your surroundings. It is a magnificent work, or play, which acts positively on all levels. We cannot emphasize this enough. Believe us, act, and results will multiply!

— Landscape Angel

God is love. As creation becomes more conscious, it expresses greater love. The essence of life, no matter what its level of consciousness, is Love. Life becomes more perfectly itself when surrounded by love. This is true of all realms of being. Humanity's greatest contribution to life on this planet is to love consciously and so to bring more health, vigor, and beauty to life.

— Landscape Angel

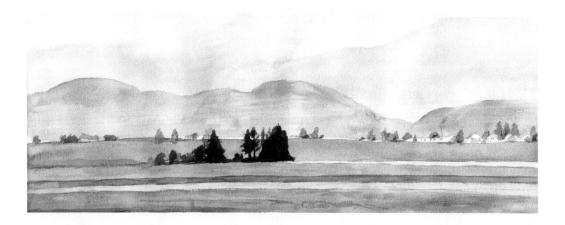

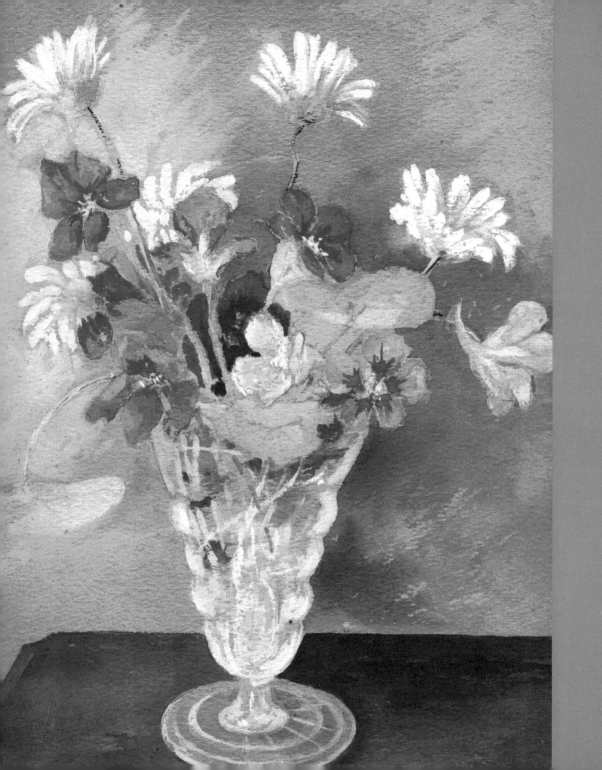

D. Maclean

We are finding increasing lightness among you, and that draws us ever closer - for we are creatures of Light; our plants grow towards the light, and we, ourselves, are of the substance of Light, and you, with light hearts, are our very selves.

I do not need to explain in scientific terms this light-heartedness we talk about; you know it in your hearts and your mind acknowledges and aids it. What you do not know is the effect this energy has on all of life, down to the densest mineral. As laughter is infectious and the whole world is said to laugh with it, likewise with light-heartedness. It has strong vibrations which overcome any resistance - not by force but by melting - and in the overcoming, lifts and fashions to a new life. Life has reached down to what seems the no-life of a solid, unyielding form, but light-heartedness opens and speeds up even that form, or makes it shine with life. You may see nothing of this, but, as water wears away stone, so does light-heartedness.

— Elecampane Deva

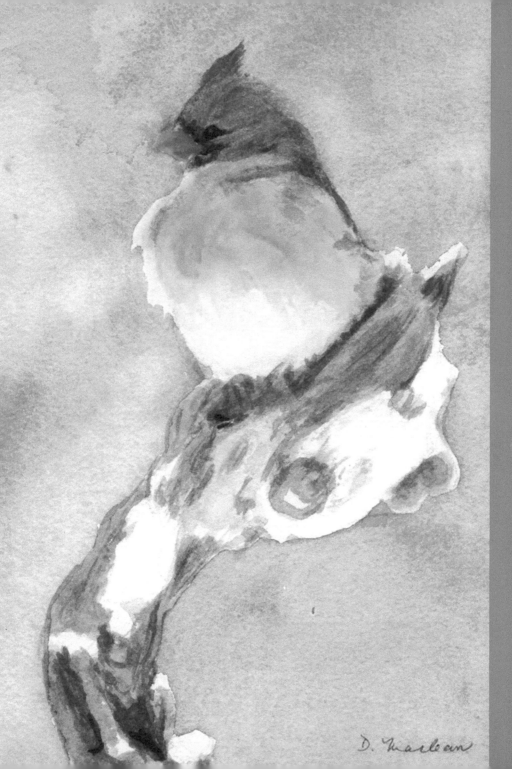

D. Maclean

D. Maclean

It is said that there is no perfection on earth; yet, everywhere you look, you can see it. It is ever-changing, moving from a flower to a dewdrop, from a bird to a sunset, from a taste to a pattern.

I have a sense of human consciousness saying that God is too mighty to speak through small things. Human consciousness thus seeks to limit God to certain categories even though the atom has proved mighty. There is nothing that is not important. All details are part of life. Every cell, every speck of dust in or out of place is important and speaks with a divine voice. Your human tasks are the ordering and manifesting of a new world. We show you how it is done in our small world and let our divinity speak to you, for what we are is what you are and that is God speaking.

— Deva of Abutilon

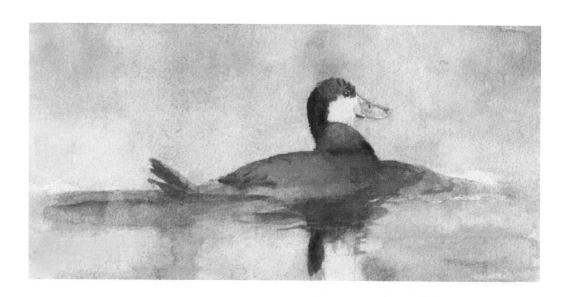

CPSIA information can be obtained
at www.ICGtesting.com
Printed in the USA
BVHW021616040521
606413BV00010B/474